250 STENCIL DESIGNS
FROM INDIA

K. PRAKASH

DOVER PUBLICATIONS, INC.
New York

Exclusive distributor in India: Super Book House ✦, Sind Chambers, Shahid Bhagat
Singh Road, Colaba, Bombay, 400 005, India.

Bibliographical Note

250 Stencil Designs from India is a new work, first published by Dover Publications, Inc.,
in 1996.

DOVER *Pictorial Archive* SERIES

This book belongs to the Dover Pictorial Archive Series. You may use the designs and
illustrations for graphics and crafts applications, free and without special permission,
provided that you include no more than ten in the same publication or project. (For
permission for additional use, please write to: Permissions Department, Dover Publica-
tions, Inc., 180 Varick Street, New York, N.Y. 10014.)
 However, republication or reproduction of any illustration by any other graphic service,
whether it be in a book or in any other design resource, is strictly prohibited.

Library of Congress Cataloging-in-Publication Data

Prakash, K.
 250 stencil designs from India / K. Prakash.
 p. cm. — (Dover design library)
 ISBN 0-486-29026-3 (pbk.)
 1. Stencil work—India. 2. Decorative art—India—Themes, motives. I. Title.
II. Series.
NK8665.I4P73 1996
745.4′4954—dc20
 95-40910
 CIP

Manufactured in the United States of America
Dover Publications, Inc., 31 East 2nd Street, Mineola, N.Y. 11501

PUBLISHER'S NOTE

THROUGHOUT THEIR LONG, turbulent history the diverse peoples of India have preserved the mystery and vitality of their art. K. Prakash, a noted Bombay textile designer and artist, has collected forty-four plates of stencil designs that capture this 4000-year-old tradition. The mandala, a Hindu symbol for the essential nature of the cosmos, is a fundamental theme and is incorporated into complex mosaics, paisleys and repeating patterns of the buds, flowers, birds and animals that have been a part of daily life in India for thousands of years. Numerous variations, ranging from the stylized to the whimsical, make this collection an outstanding sourcebook for everything from metalwork and jewelry to textiles and graphic designs.

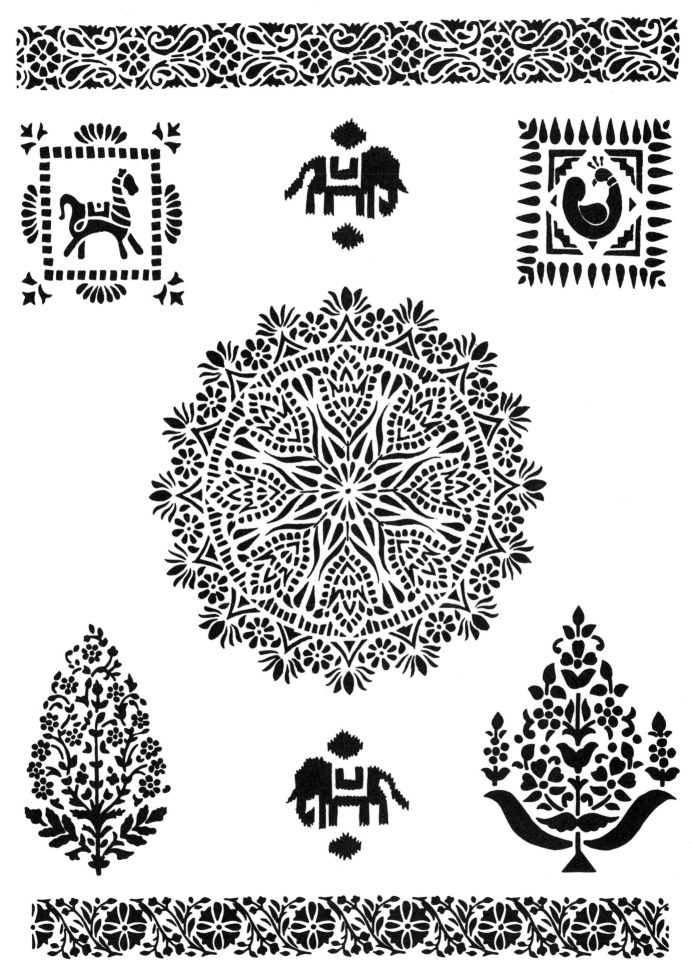

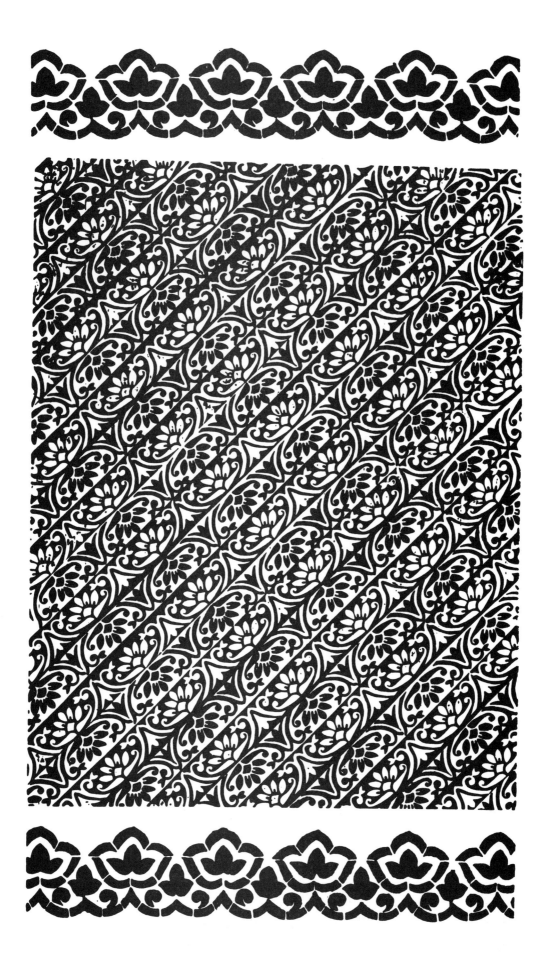

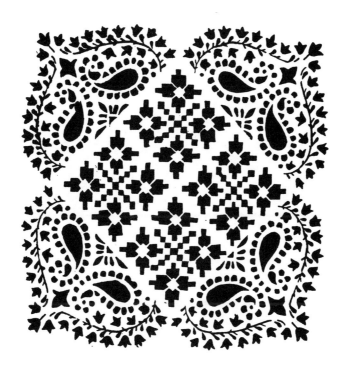

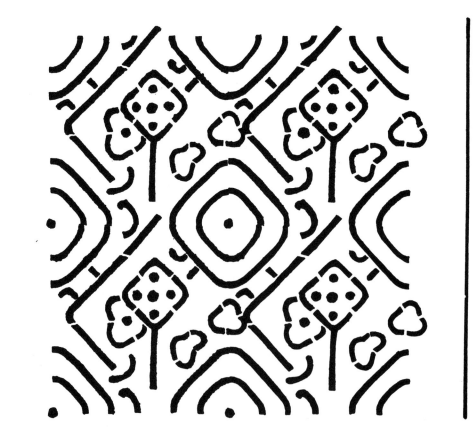

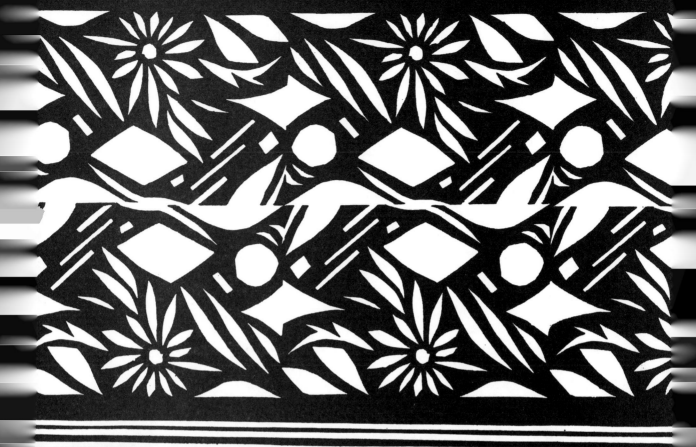

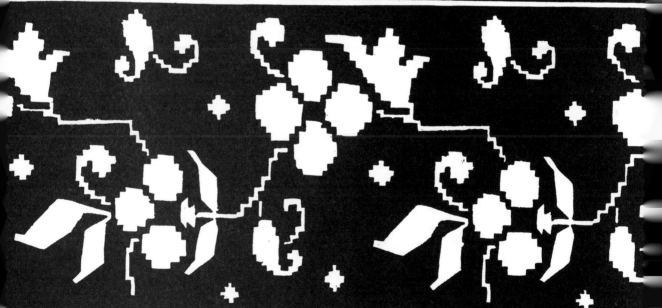

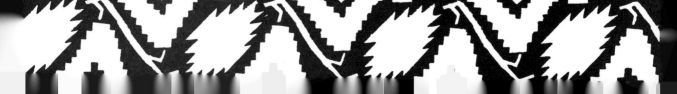

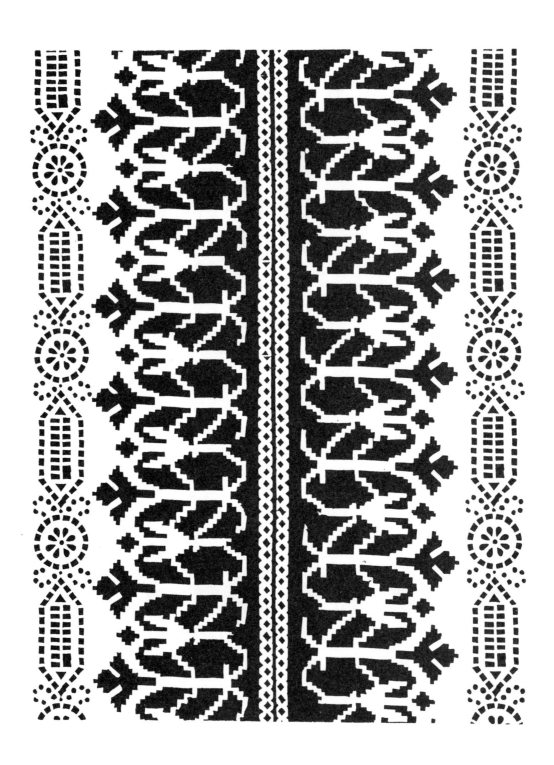

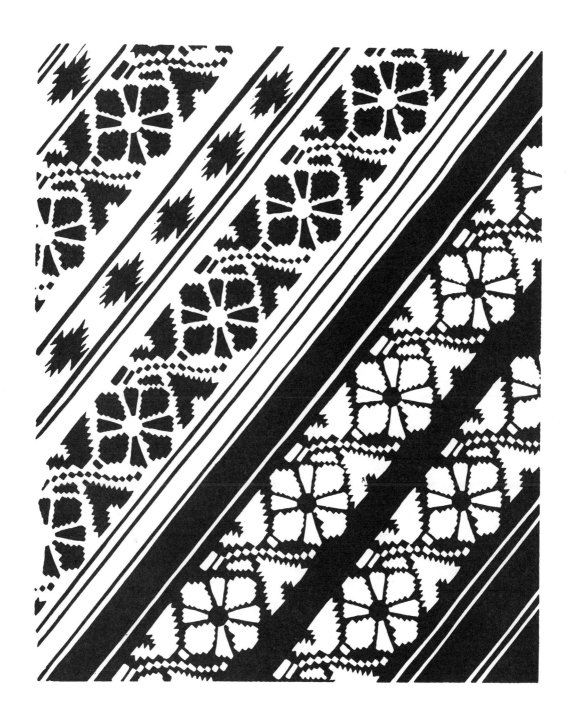

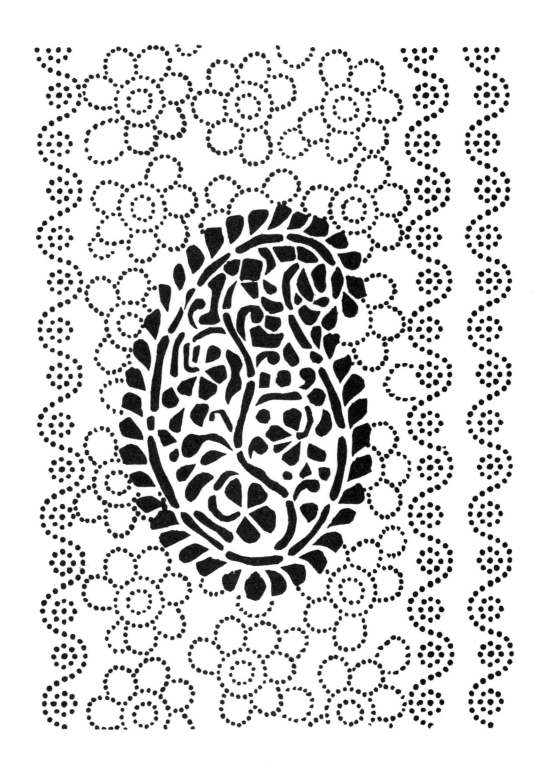

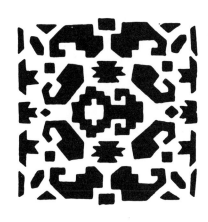
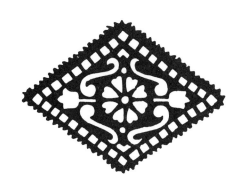
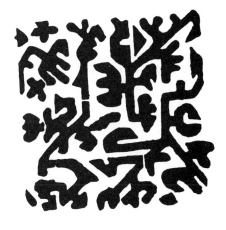
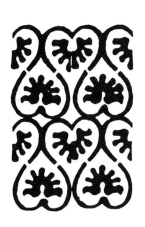
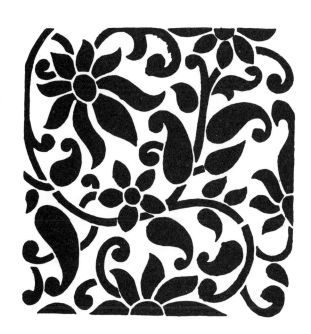
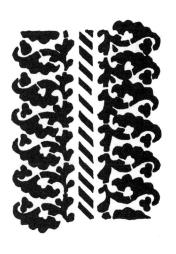
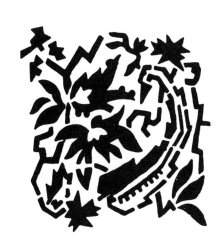
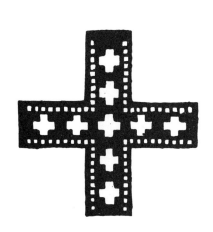
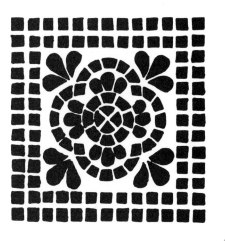

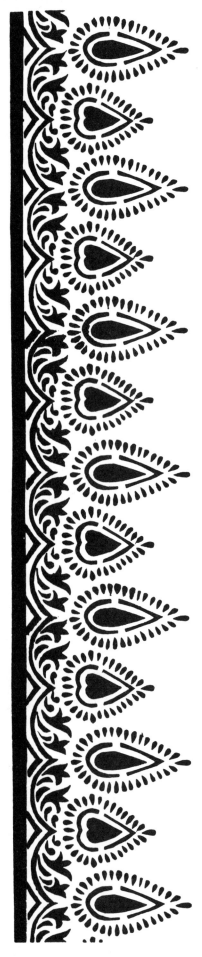
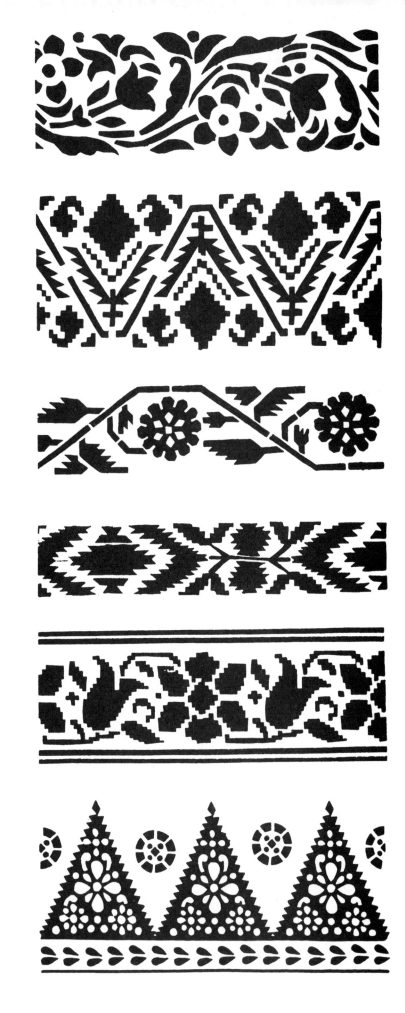

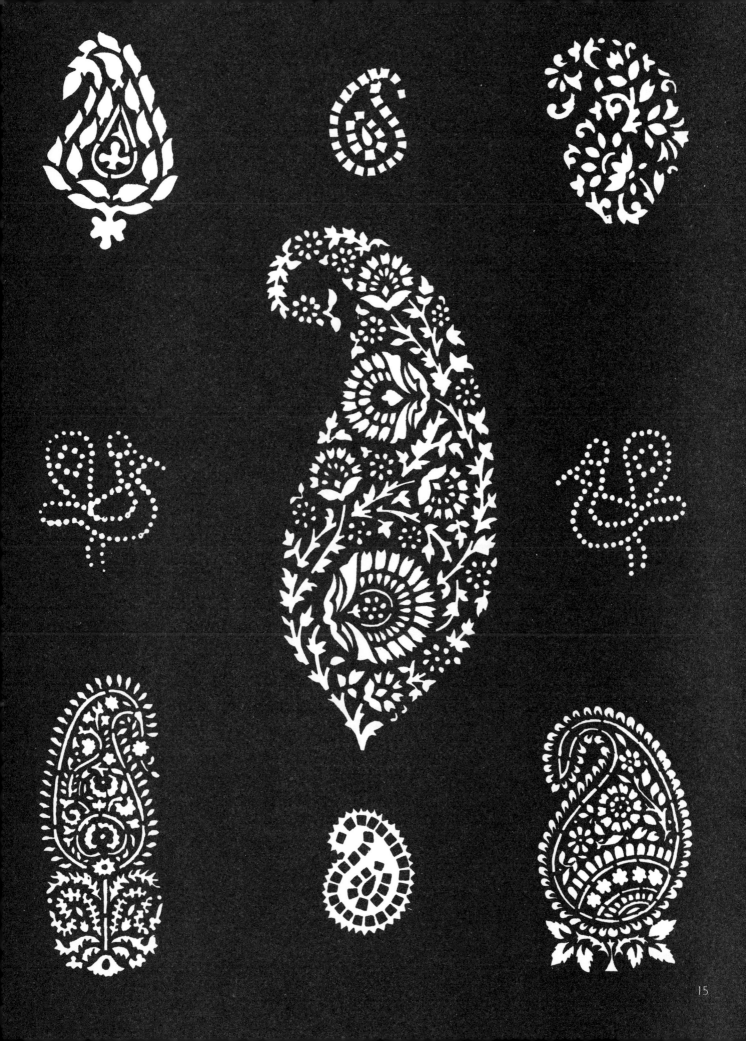

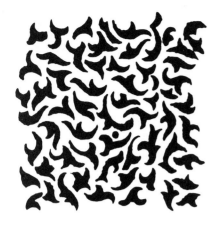

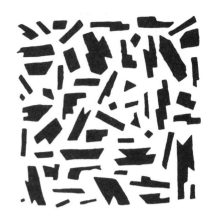

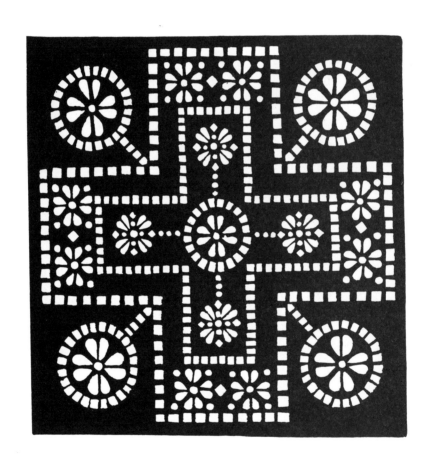

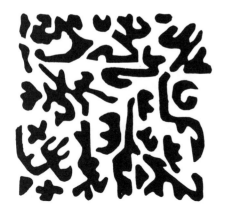

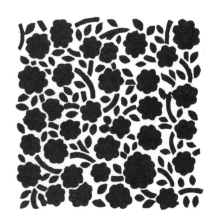

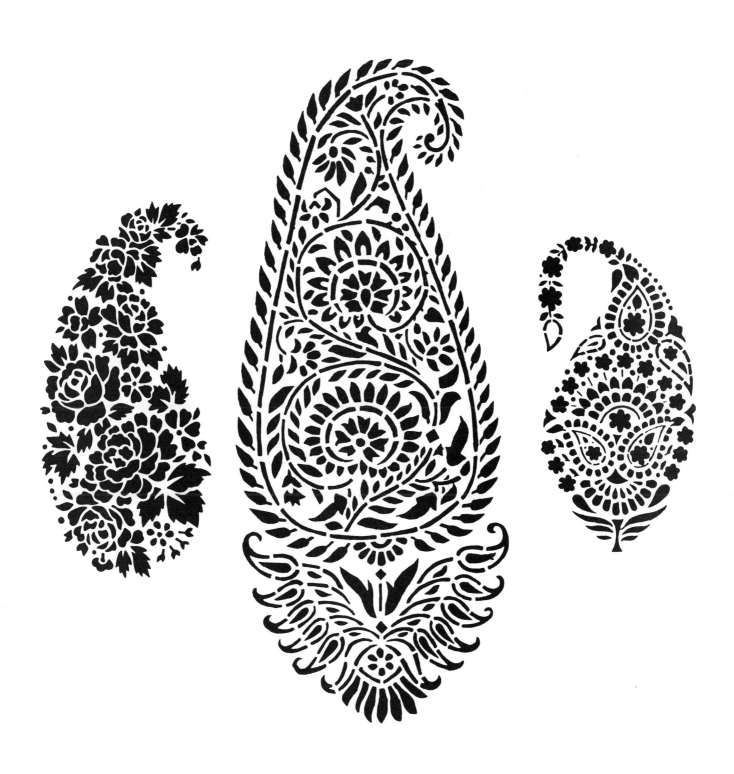

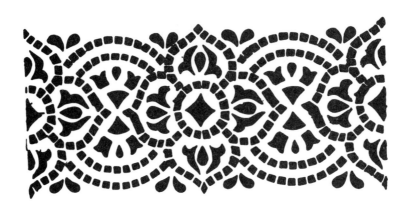

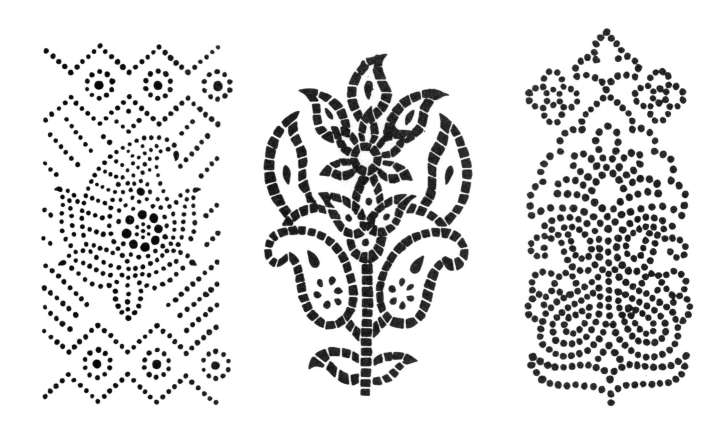

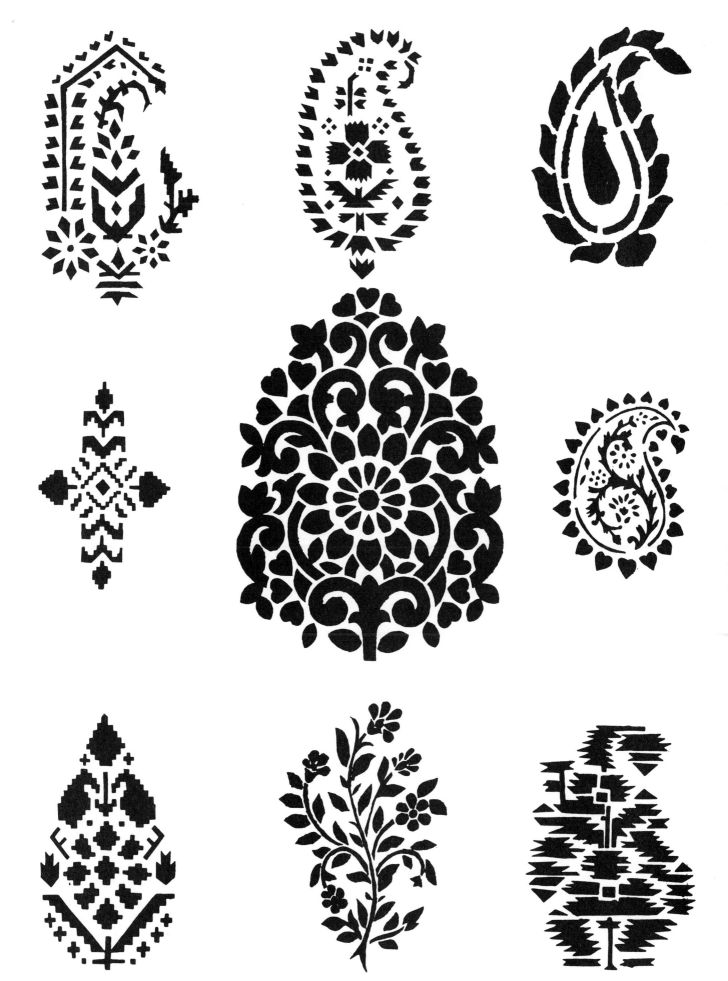

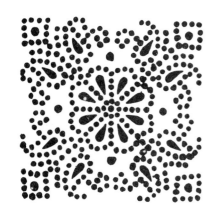

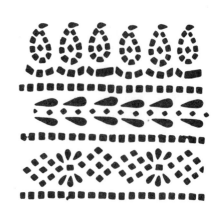

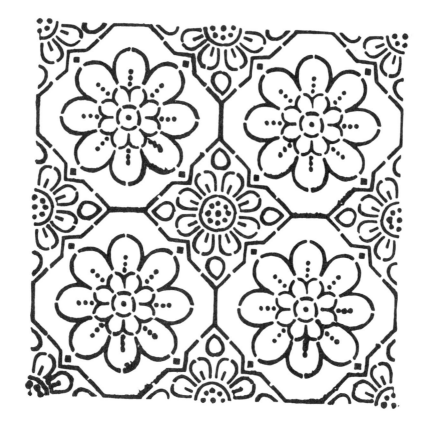

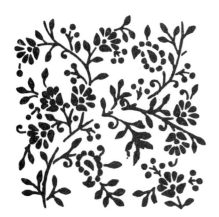

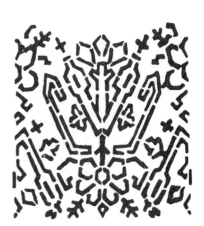

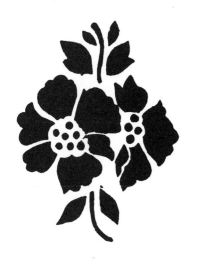
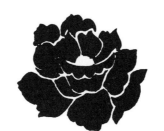
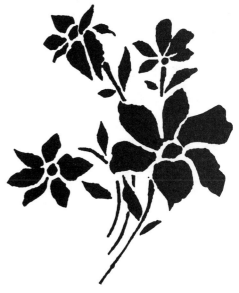
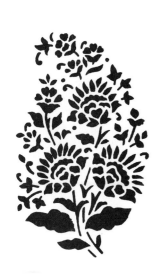
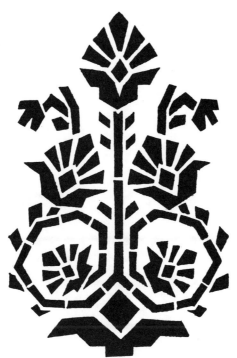
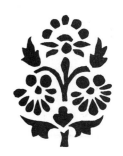
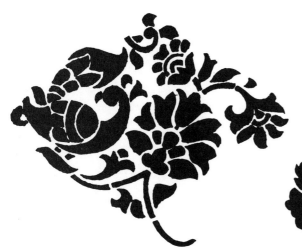
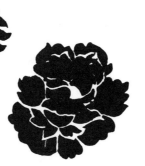
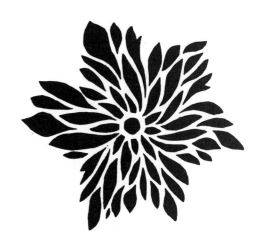

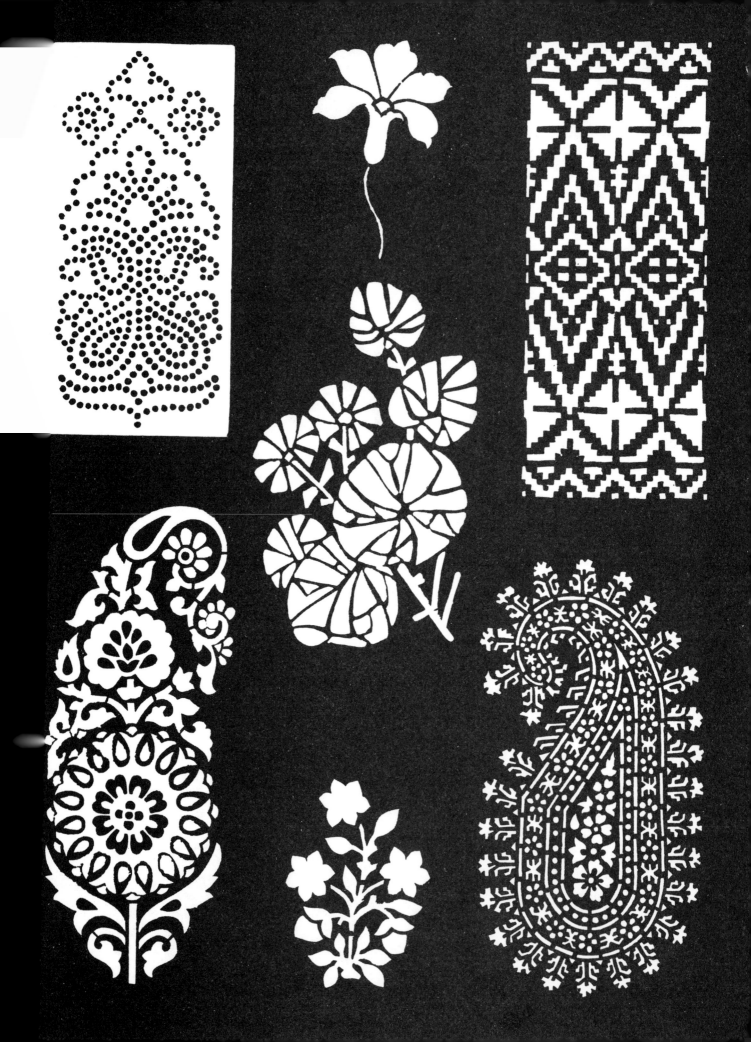

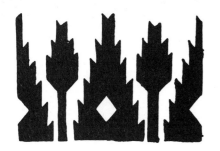
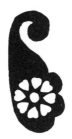
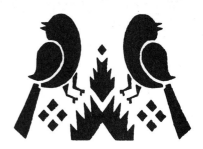
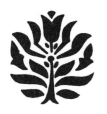
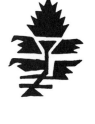
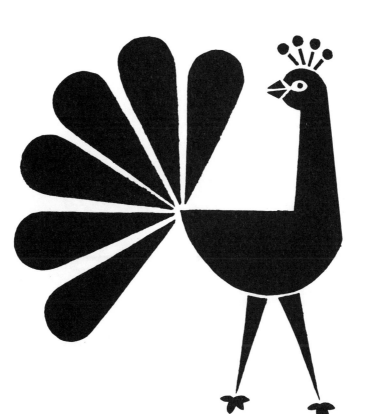
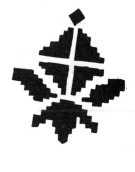
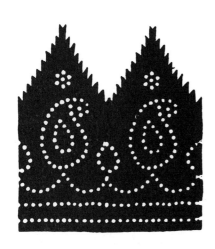

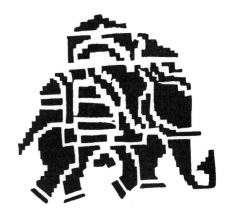

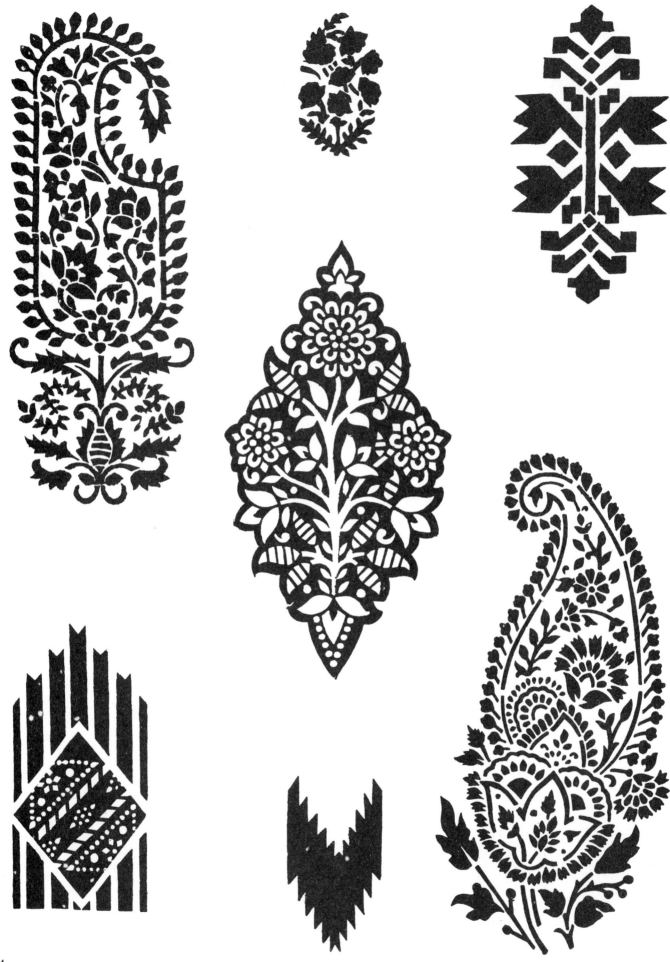

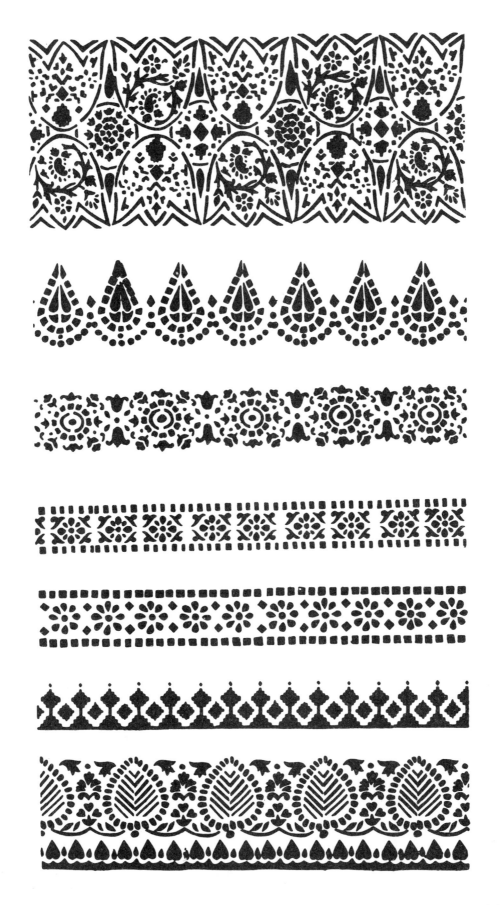

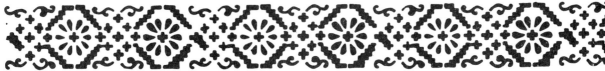

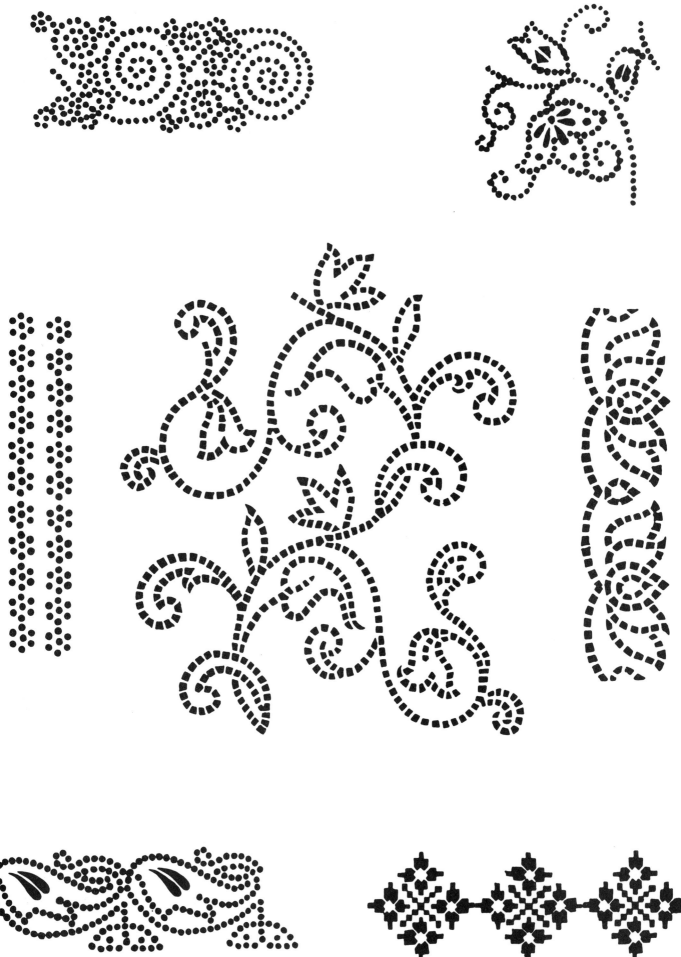

26

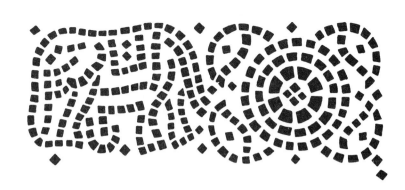

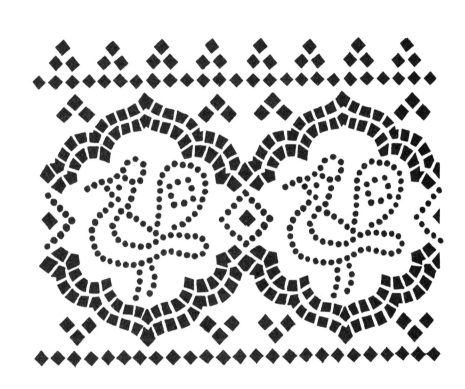

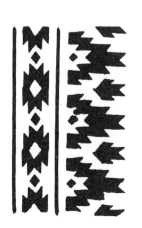
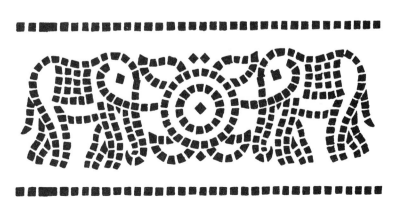
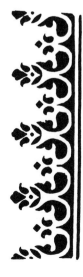

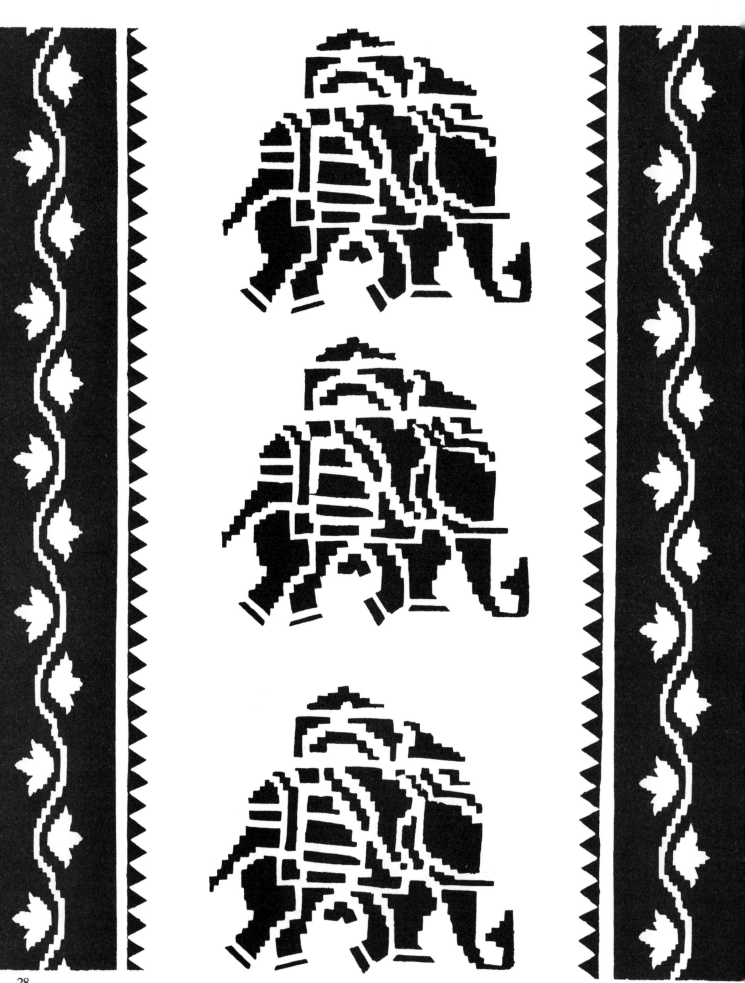

28

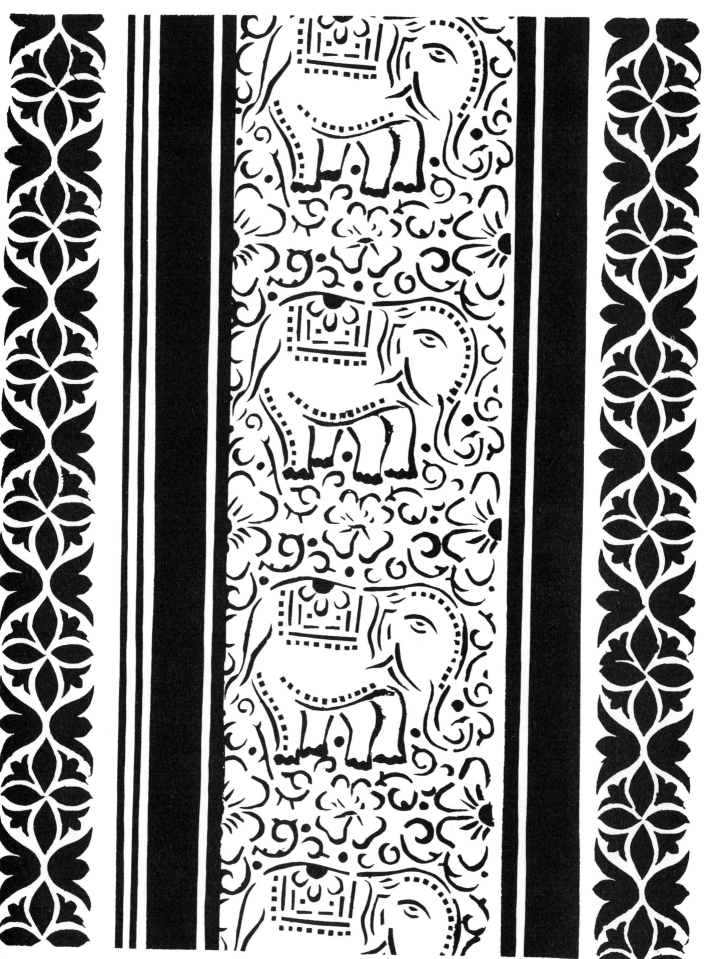

30

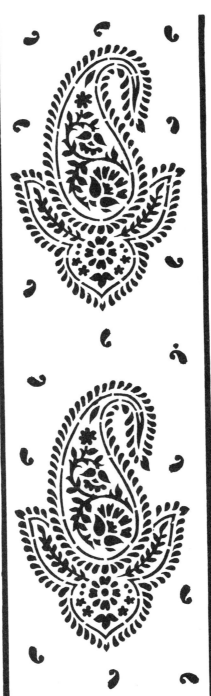

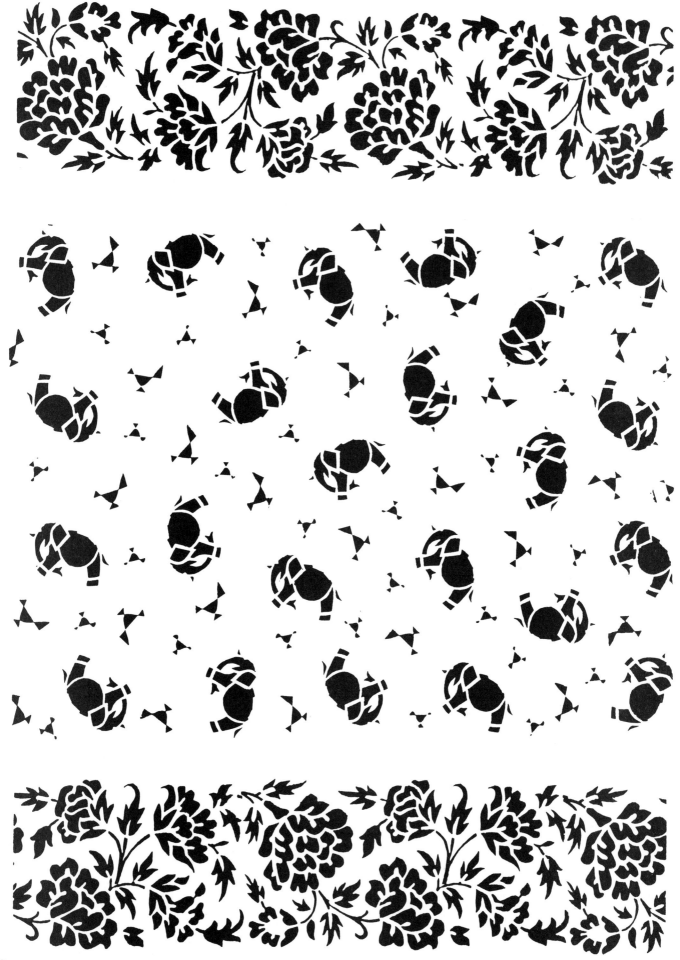

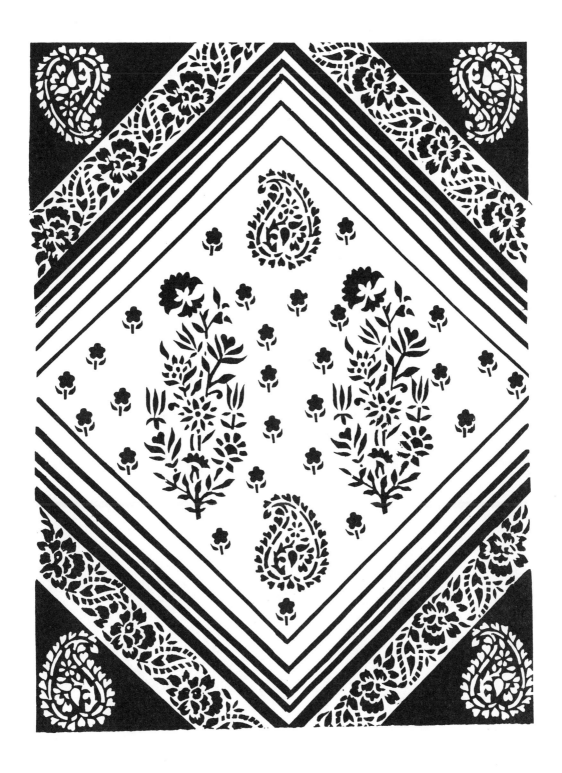

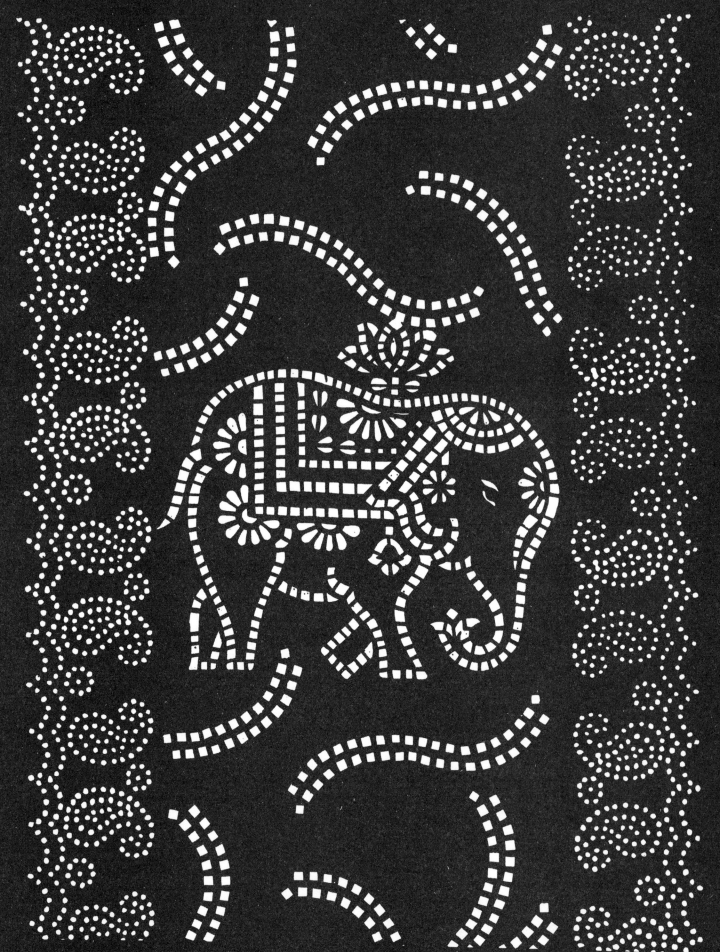

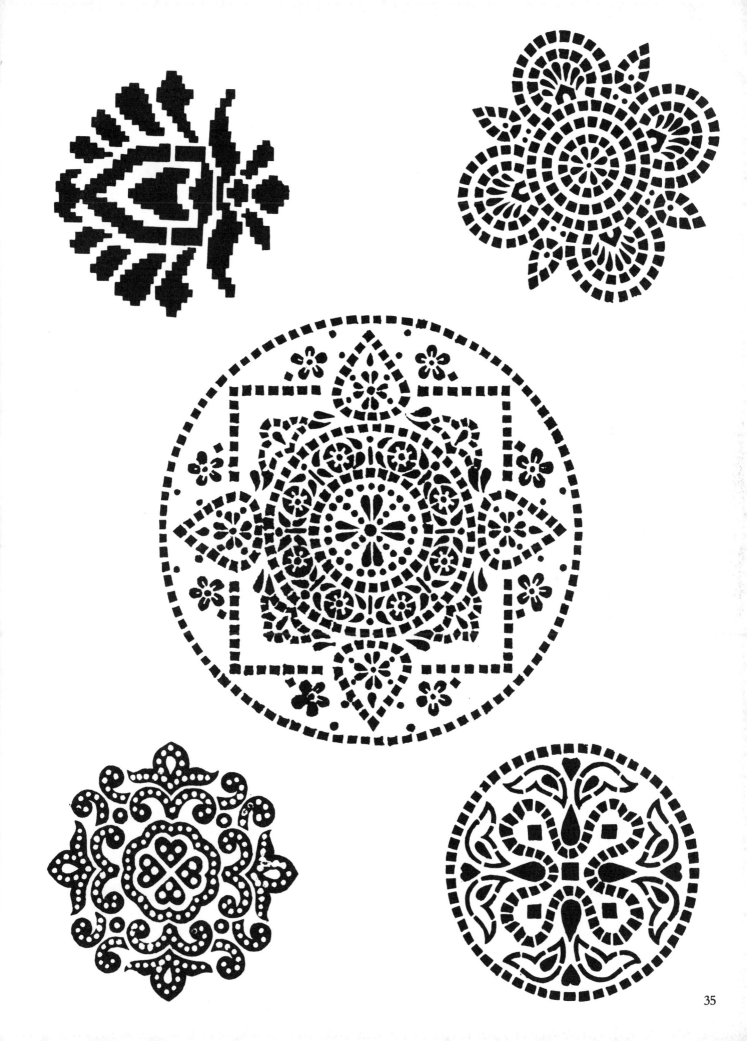

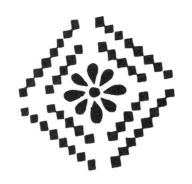
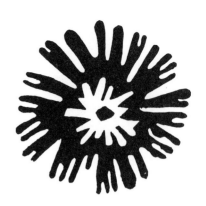
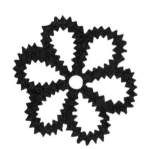
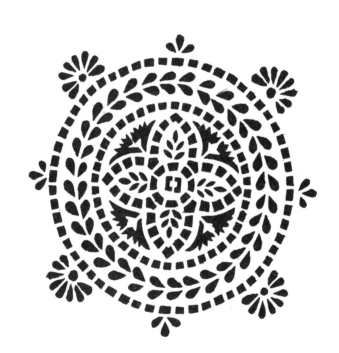
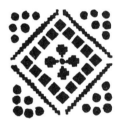
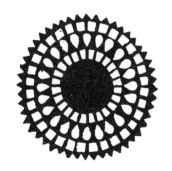
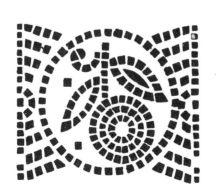
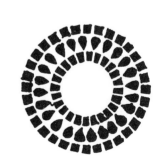

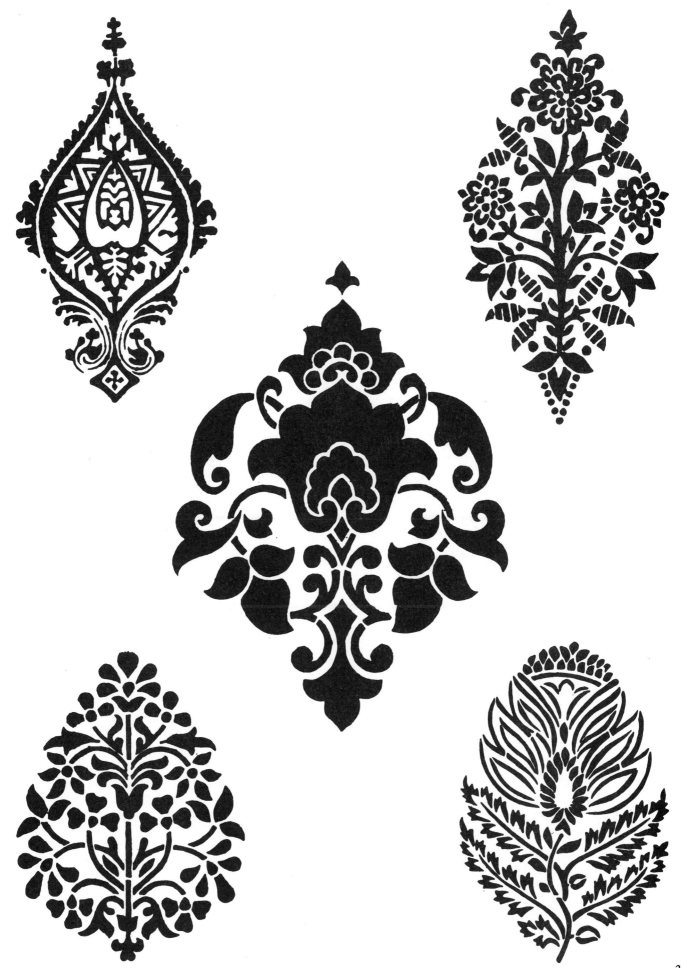

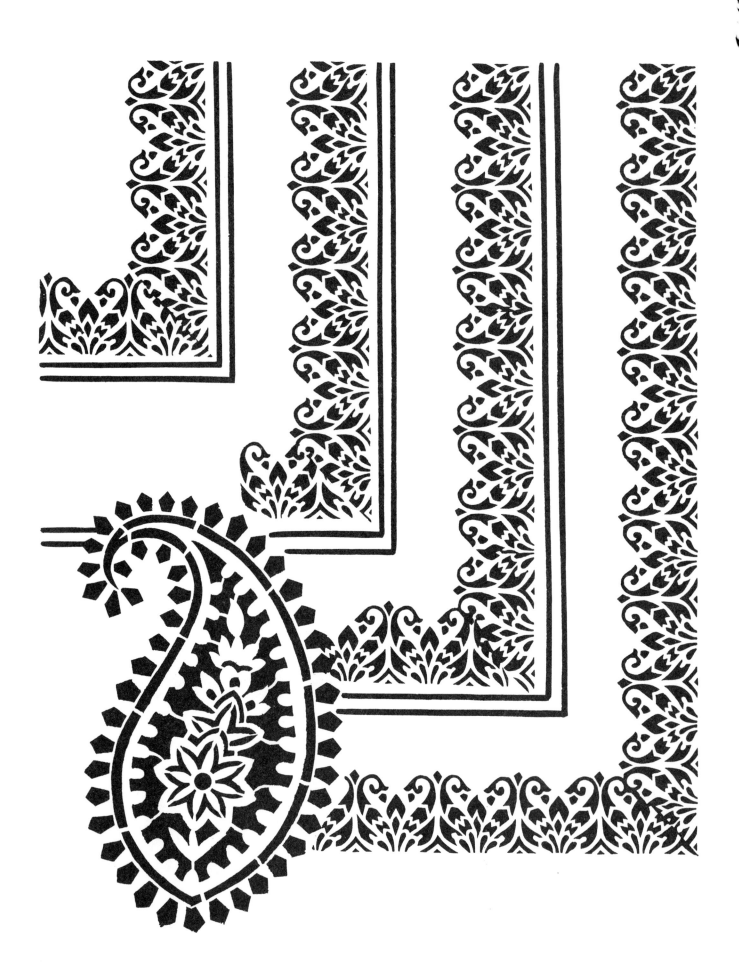

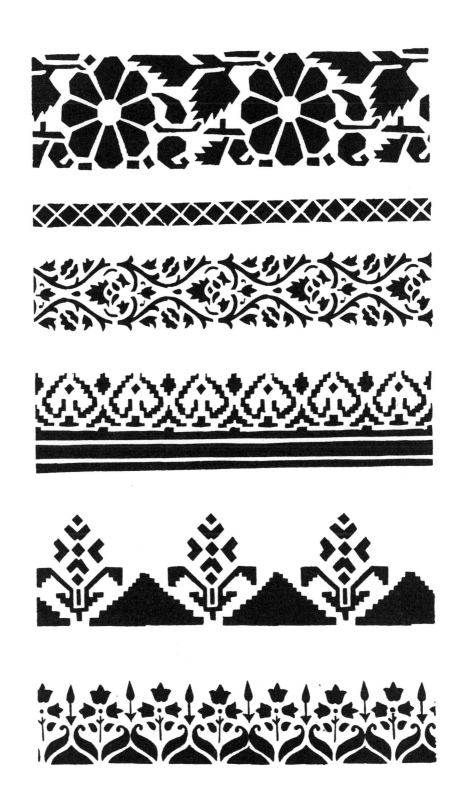

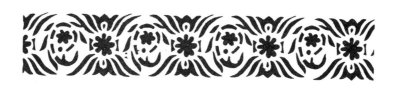

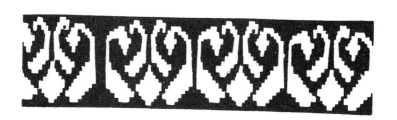

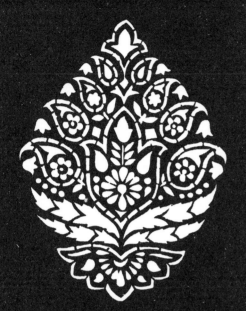
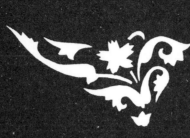
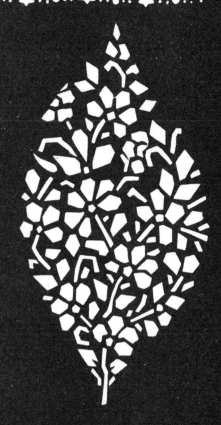
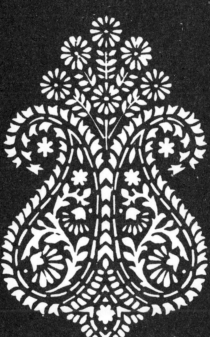
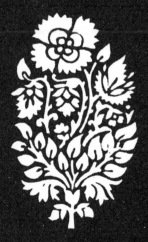

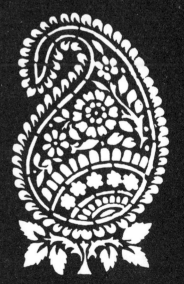

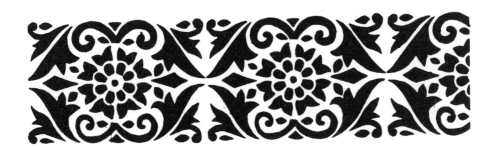

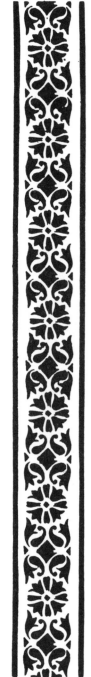

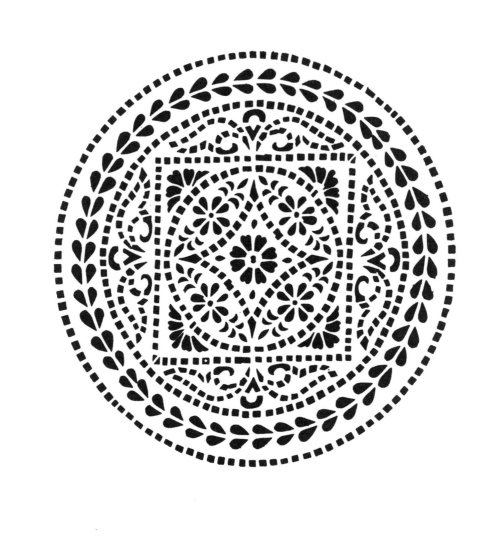

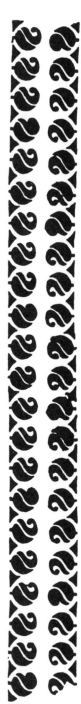

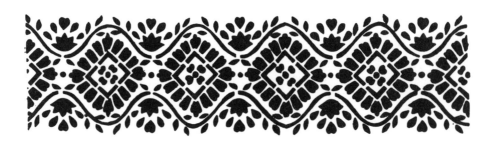

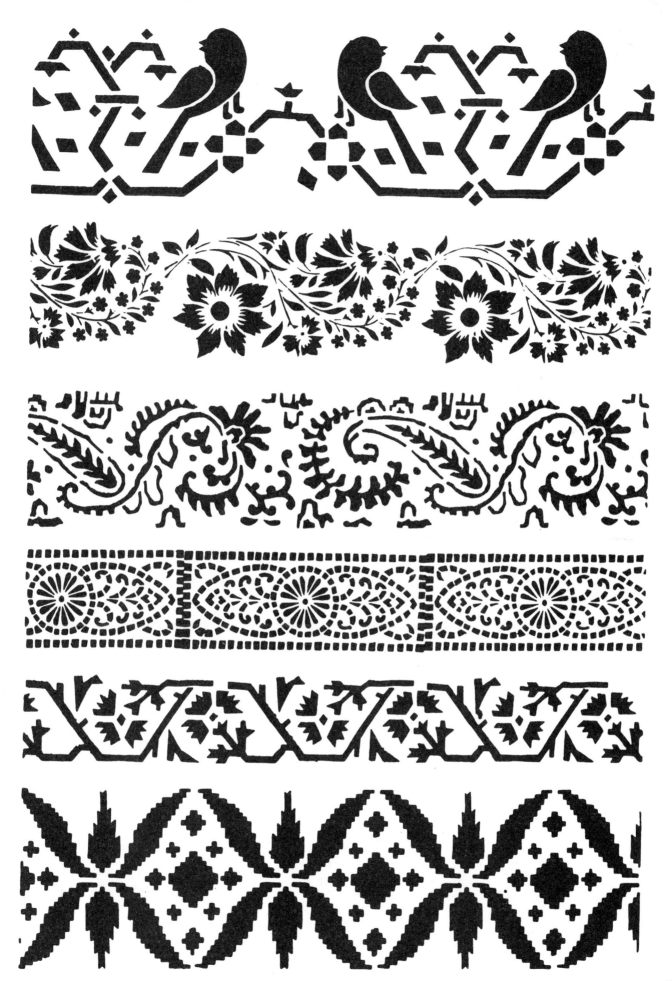

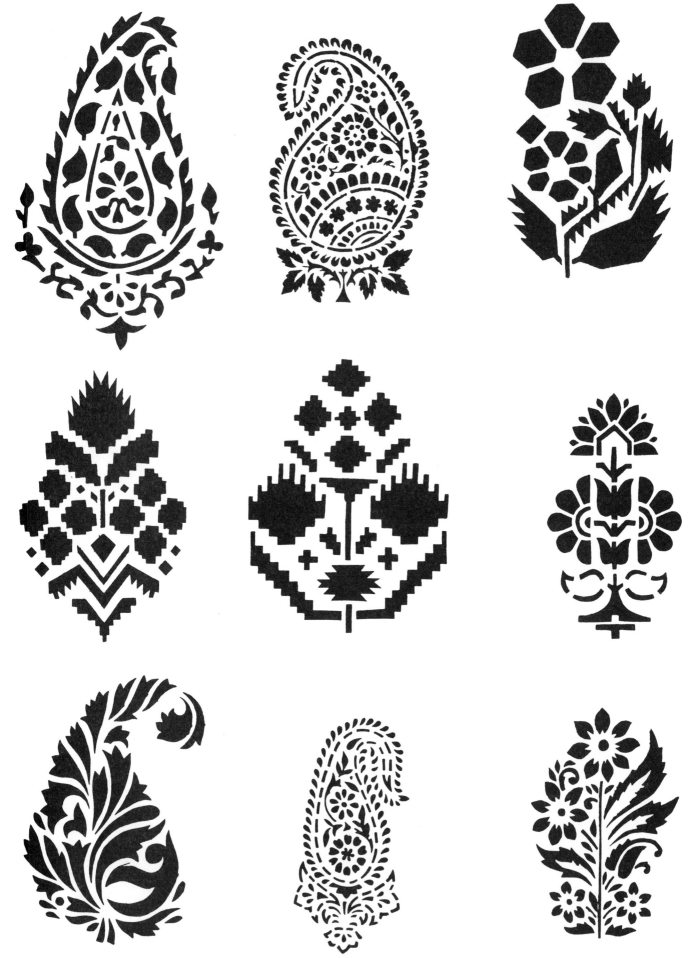

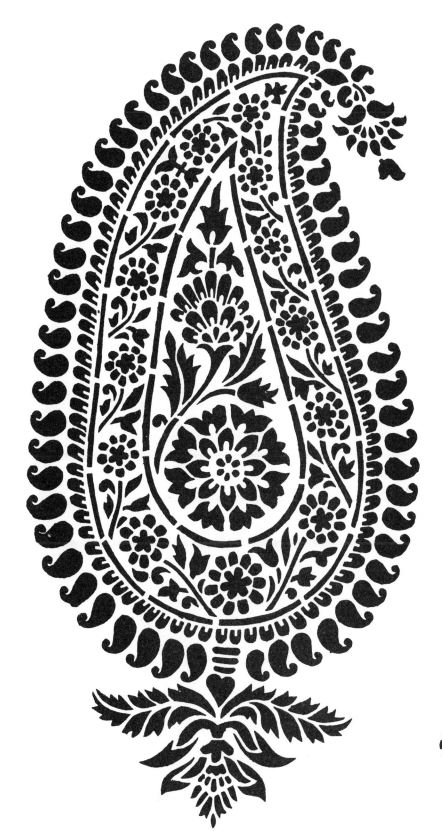

45

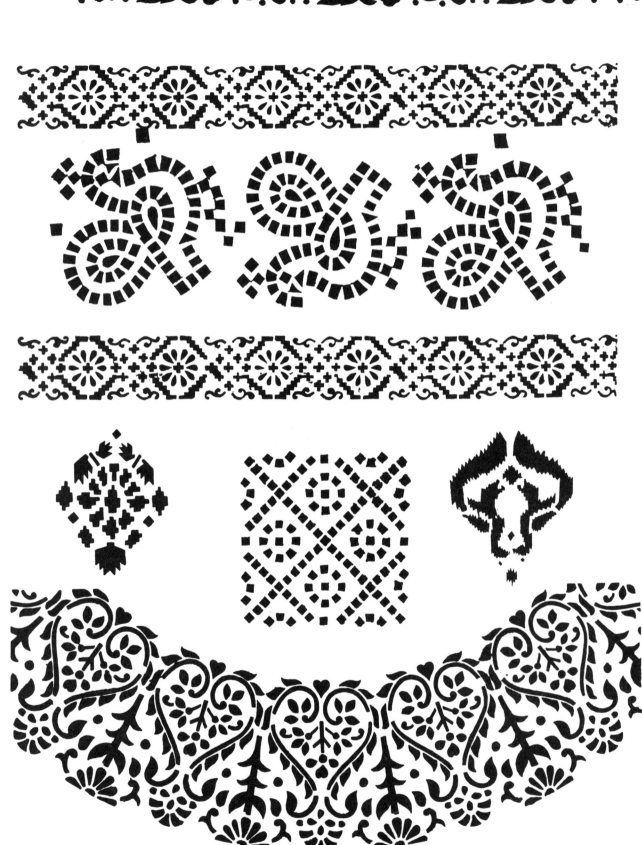

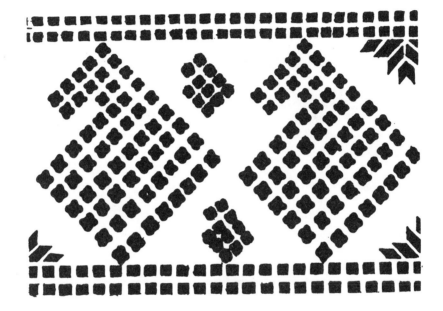

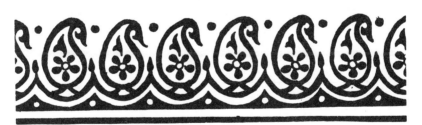

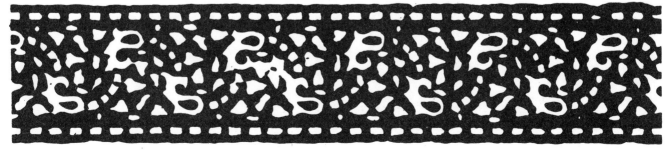

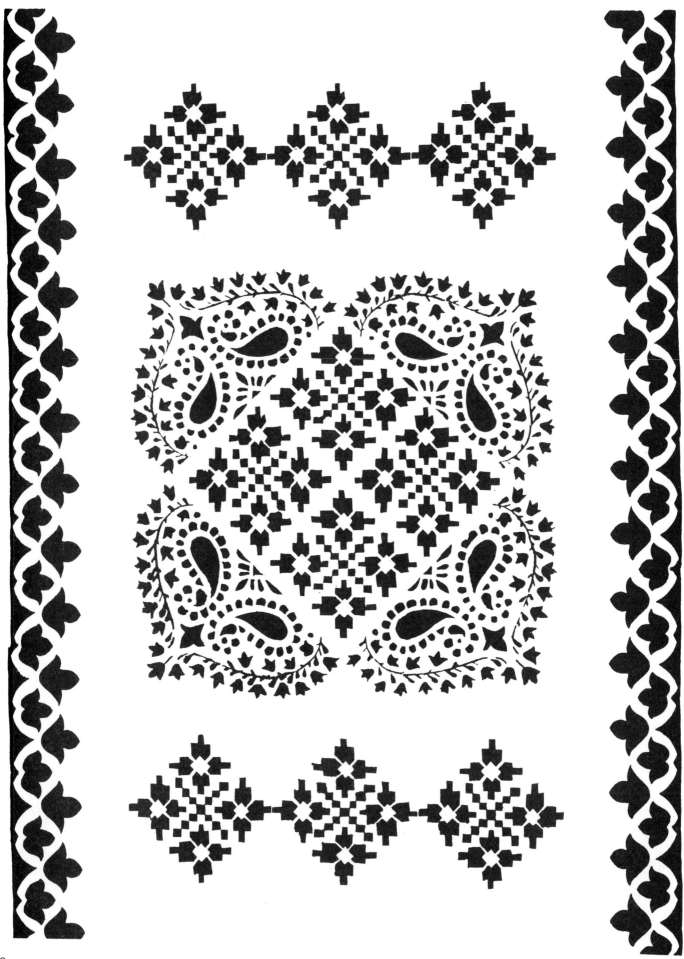